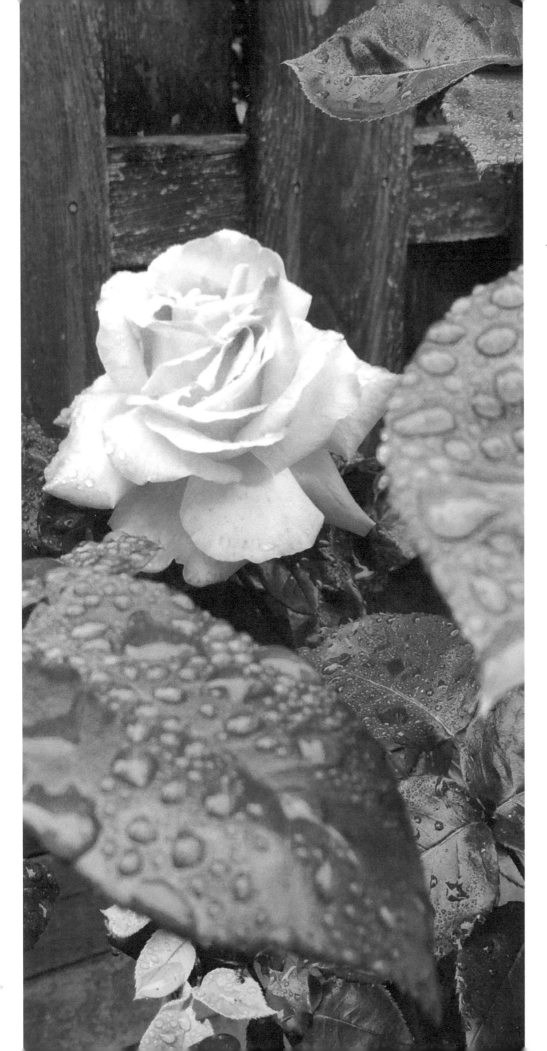

Lonely Rose

Lonely Rose,
Don't be afraid

Lonely Rose,
There'll be a day

Lonely Rose,
He'll find his way

Lonely Rose,
With you, he'll stay

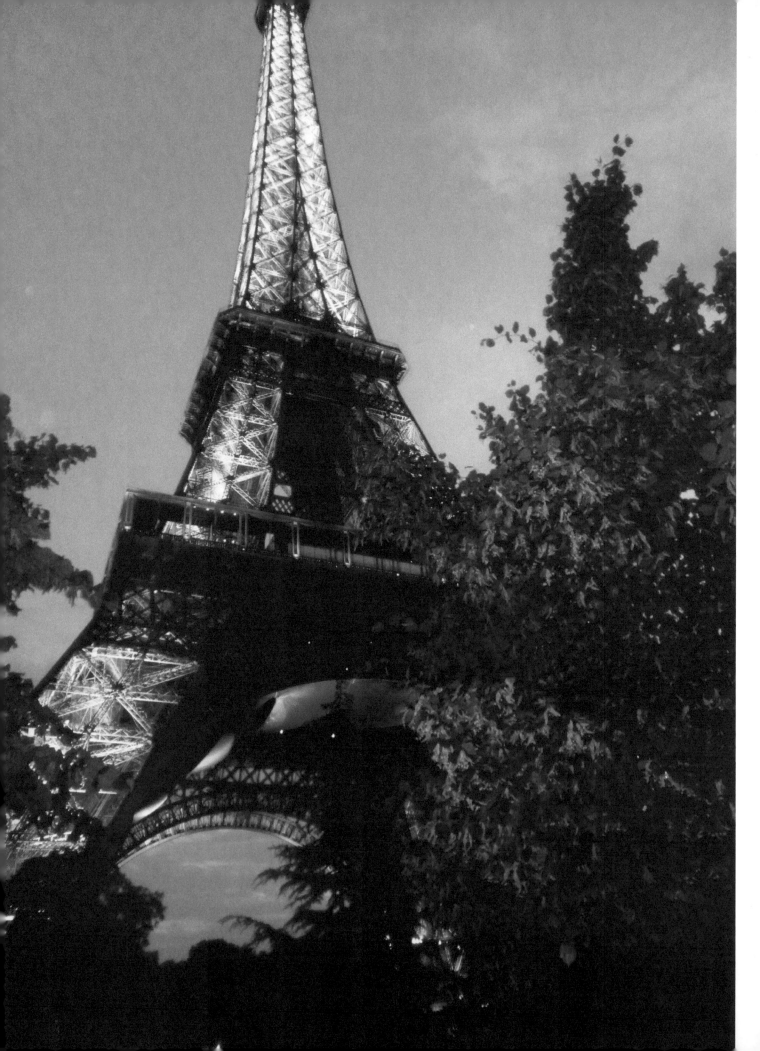

PARIS AT NIGHT

Your Eiffel Tower burns bright;

Your Lovers' locks hang tight;

Your Louvre's life slumps;

But your Arch still triumphs

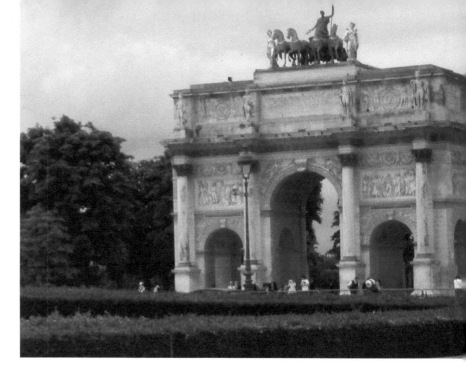

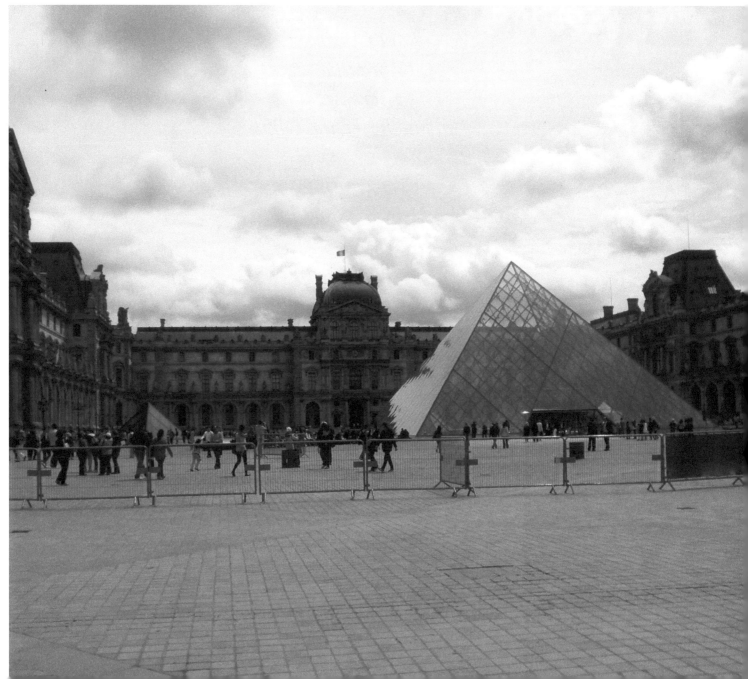

STRENGTH

Your strength,
Your power,
Your motion,
It's much like the ocean;

I ride,
I breathe,
I scream,
I'm much like the wind;

Ever waiting,
Until you come in;

The surf is right,
Your embrace is tight;

Thanks to you,
A very good night.

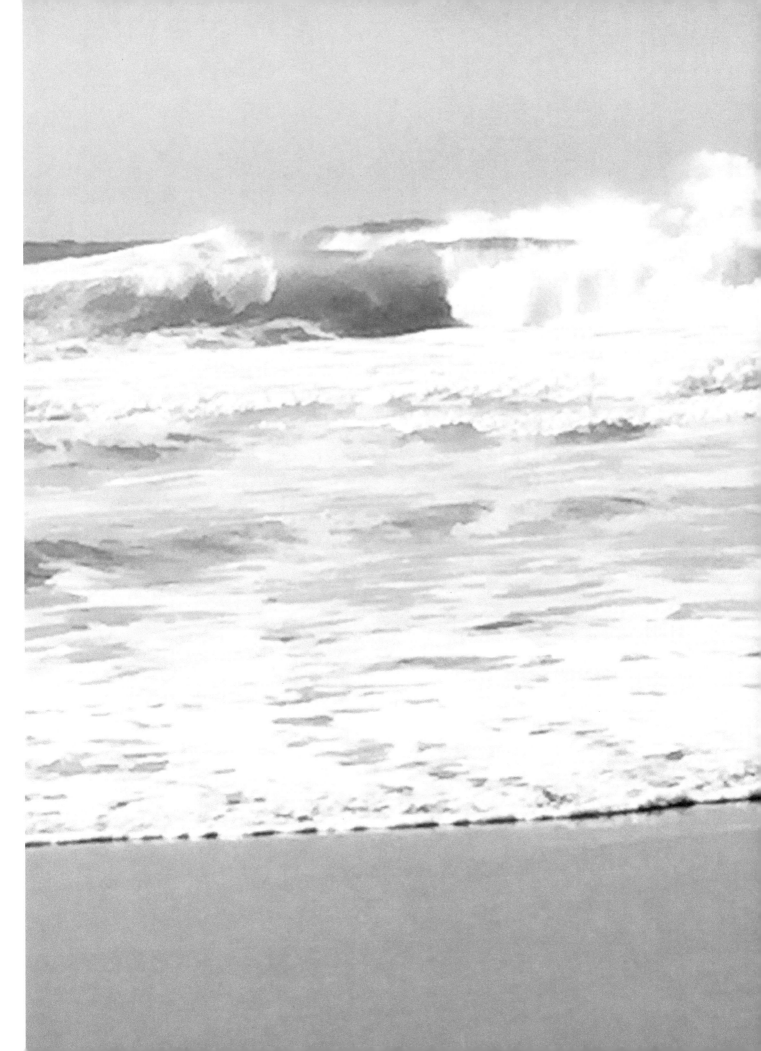

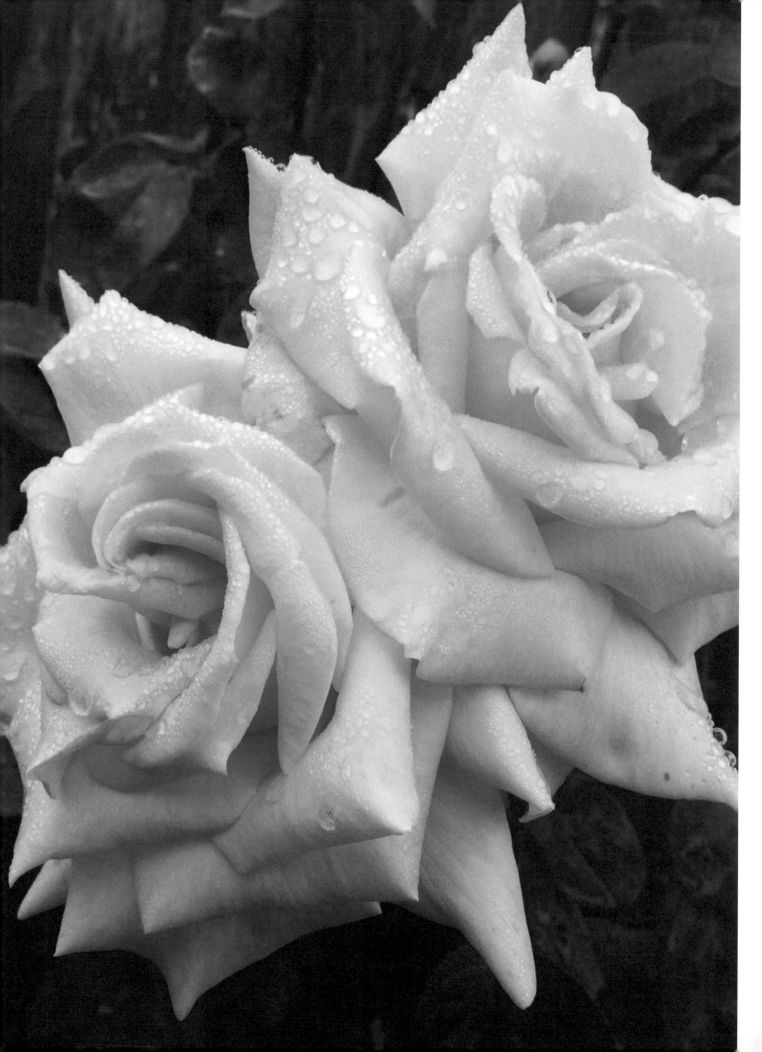

OUR STORY

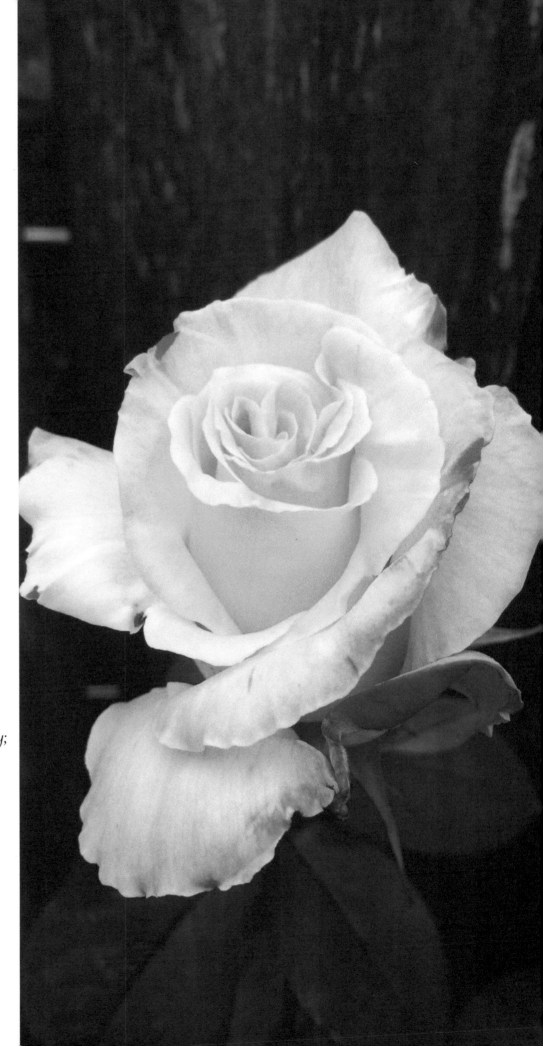

I loved you,
But you were impatient;

I loved you,
But you wouldn't wait;

I loved you,
Slowly, Cautiously, Timidly;

And you loved me,
But you wouldn't wait;

I loved you,
Slowly;

You loved me,
Immediately;

I loved you,
Cautiously;

You loved me,
Passionately;

I loved you,
Timidly;

You loved me,
Roaringly, Eagerly, Excitedly;

And I loved you,
But I was too late.

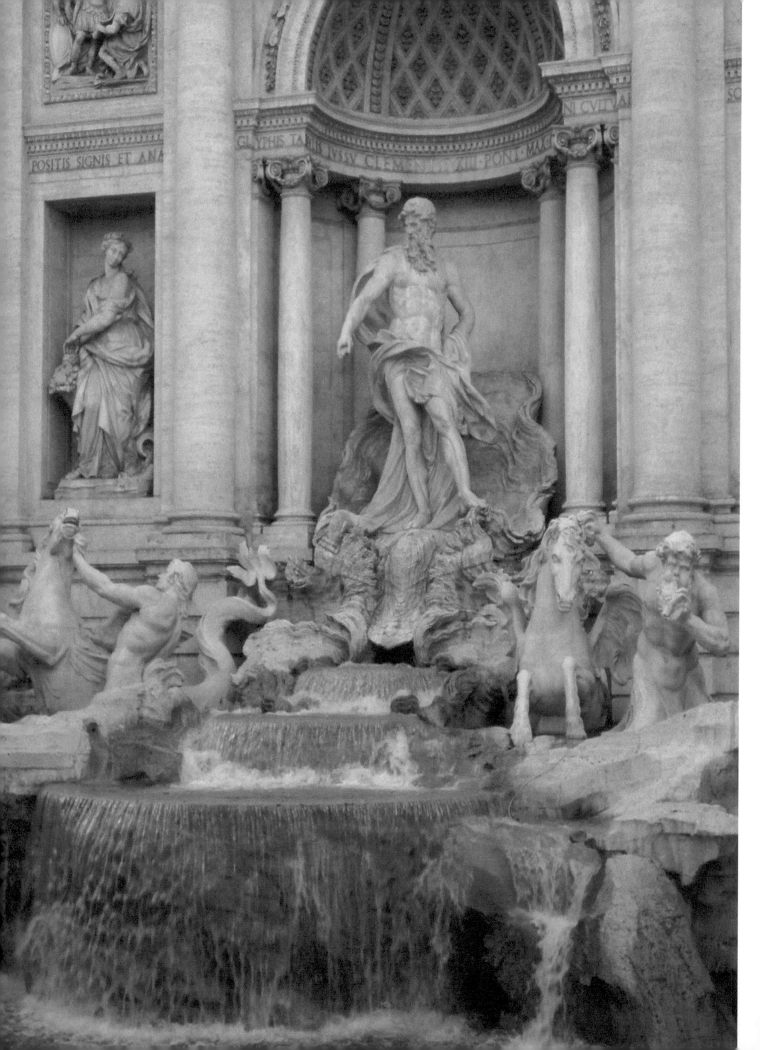

TREVI FOUNTAIN

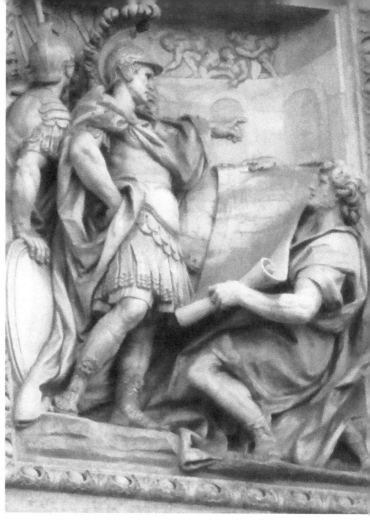

Lost in Rome, I find a fountain;
Tis grand, majestic -- like a mountain

My love is lost, but I am found
Into Trevi Fountain, my coin is bound

A wish for you,
Will it come true . . . ?

. . . Neptune, please, bring him hither
If you fail, my love will wither;

On roads I know not, he doth travel,
Neptune, please, you must unravel

These mysteries, I ask you please,
His calls, so vague, they are a tease

What do you see?
His love for me?
Or, doth he even protest thee?

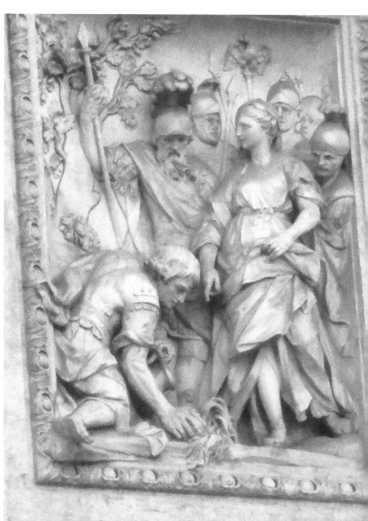

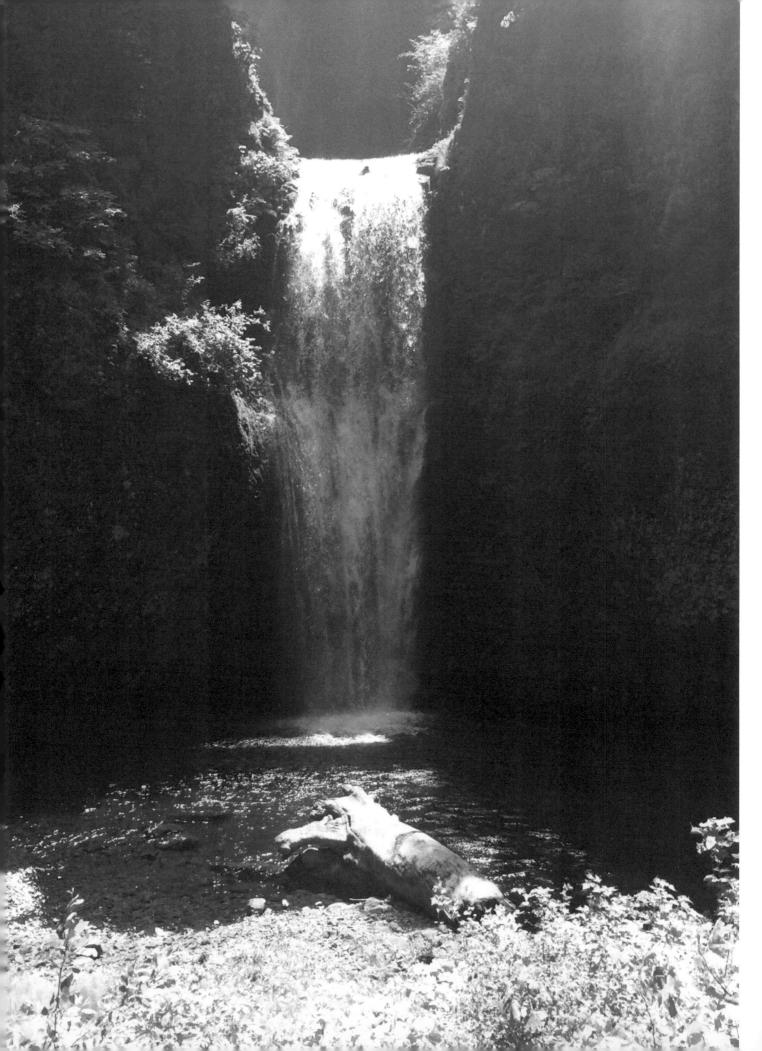

David and Sarah

A maiden, though powerful
A womanizer, though soft

A woman, so careful
A man, so lustful

A girl, so innocent
A boy, but sensitive

Boy meets girl;
and their worlds twirl

His lust turns to love,
protection, yearning;

Her innocence becomes lustful,
craving, careless;

But he is careful;
and she is confused

Then innocence meets desire
in the Garden of Eden

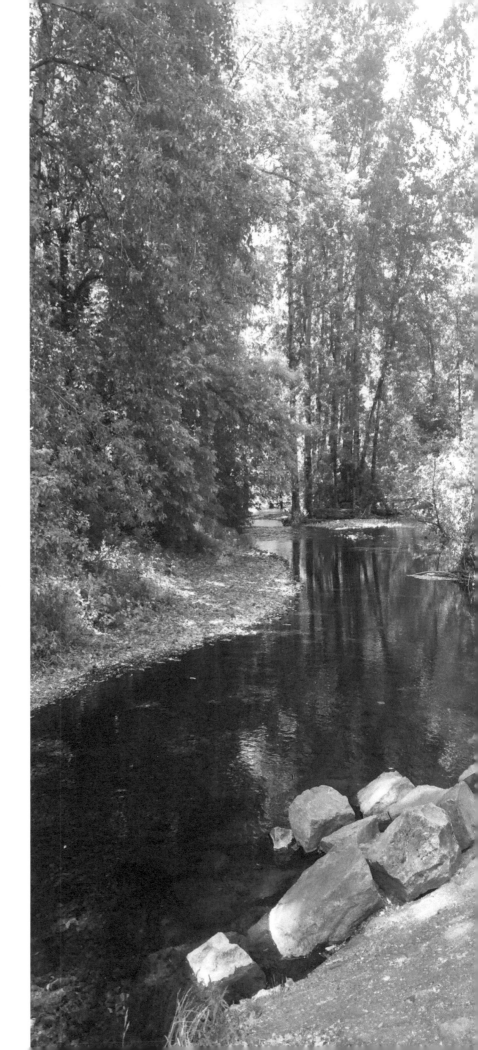

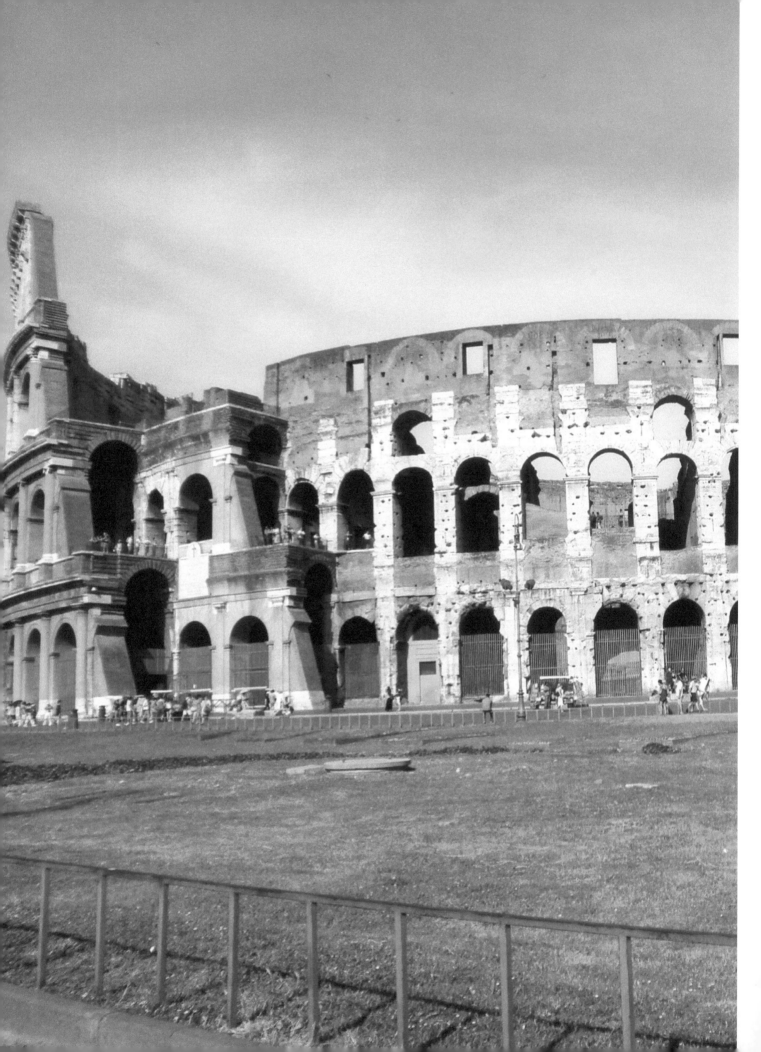

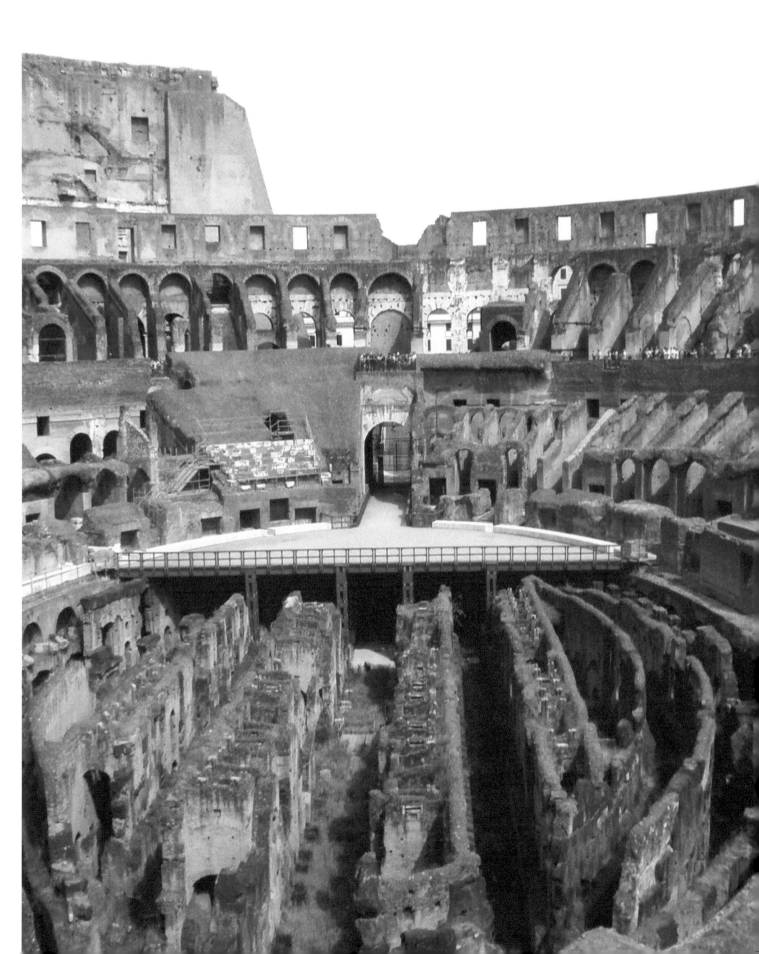

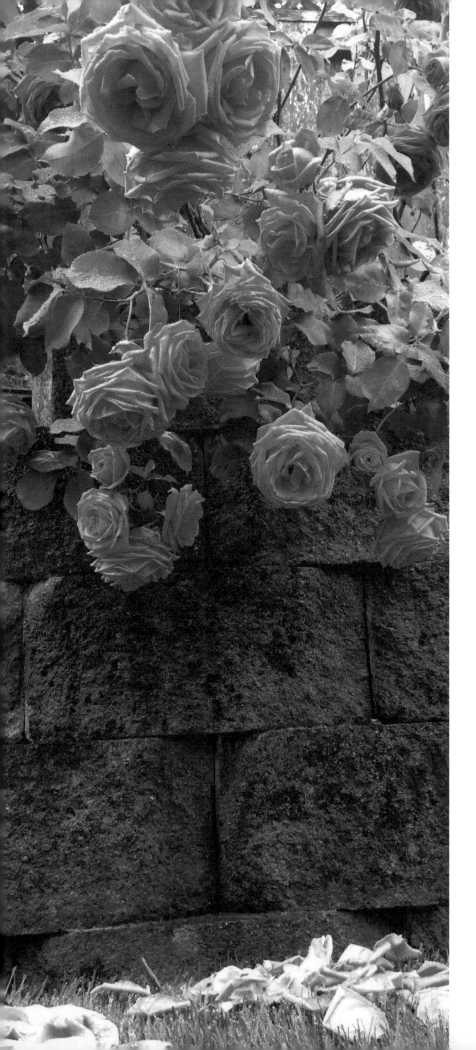

DANGER

Danger lurks outside the garden . . .

Unaware, blissful, free,

David and Sarah love with glee;

Then, a catastrophe

Love will be tried,

But will it be true?

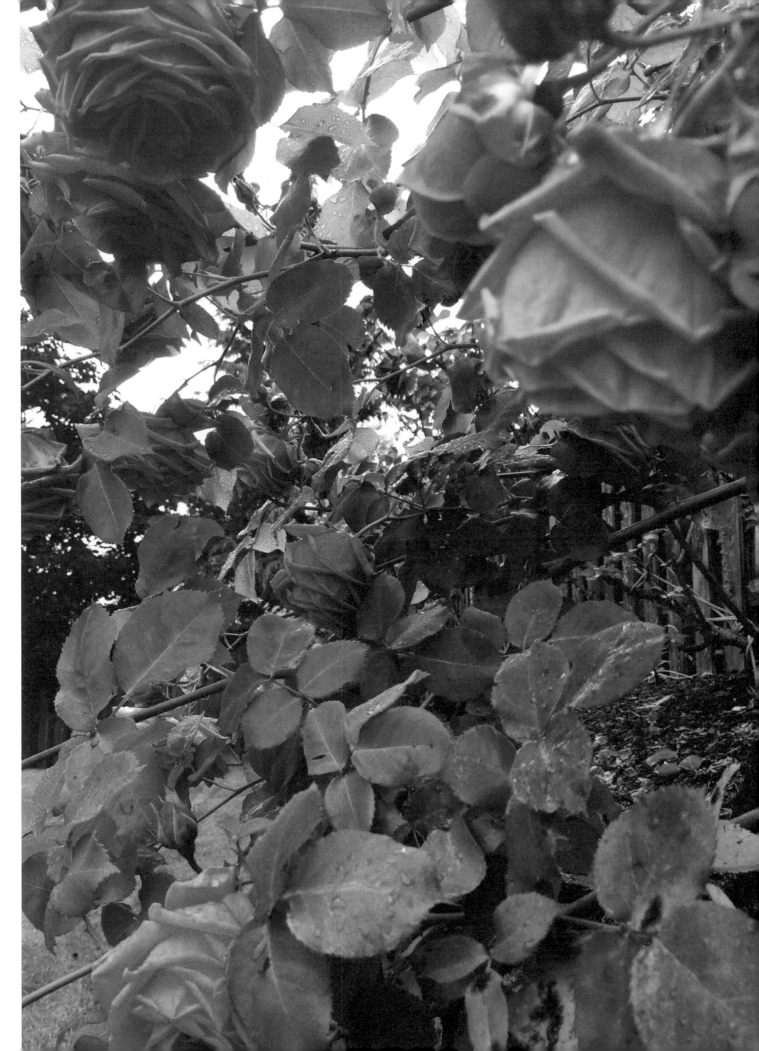

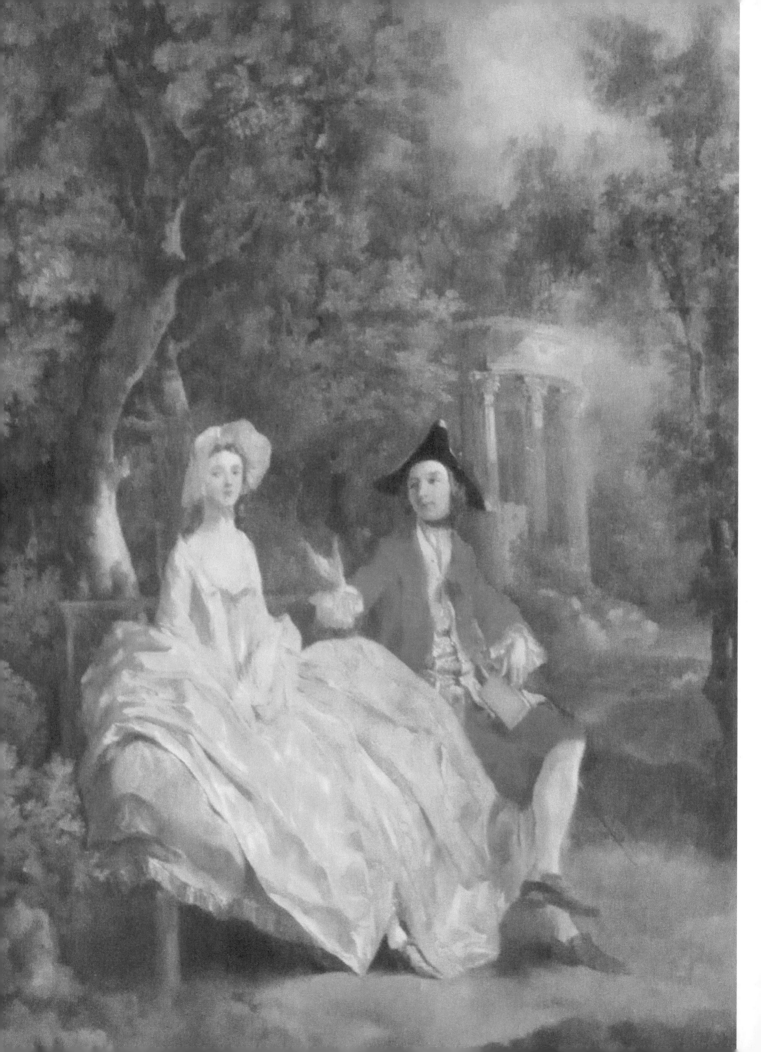

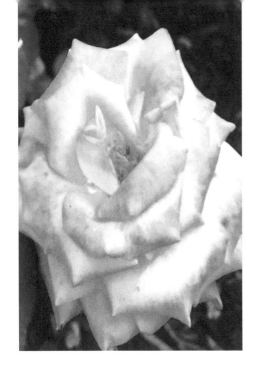

THE BENCH

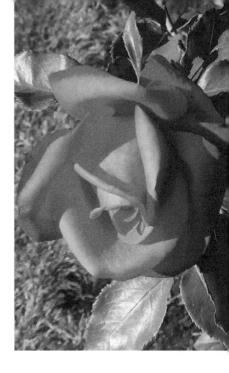

Beneath this wood, our names are carved
Cut long ago, before our hearts were scarred

You, just a girl;
Me, a boy in love;

On the ground I knelt,
And a squeal, you did belt,
Precious as a dove;

Below your skirt you thought I meant,
But beneath the bench is where I went,

To carve our names, with love's delight
Though I did give you, quite a fright

Etched not in stone,
Our love has grown;

It lives today,
Traversing trials;

Through tribulations,
With you, I'll always stay

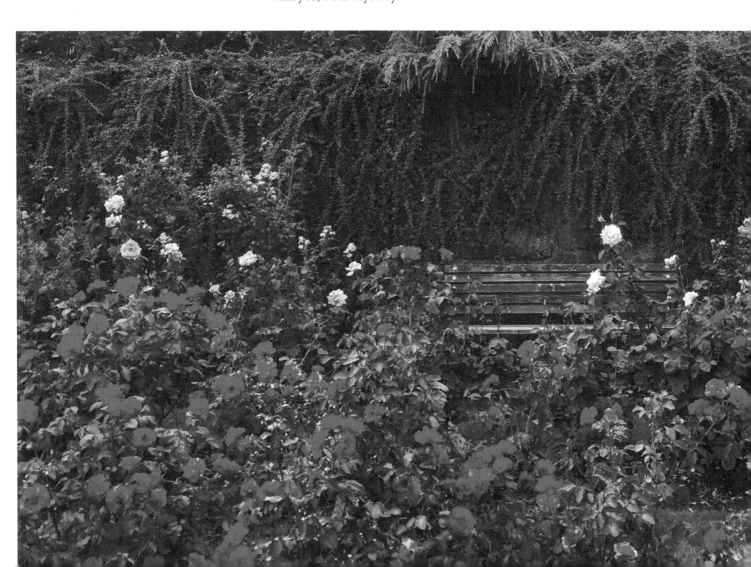

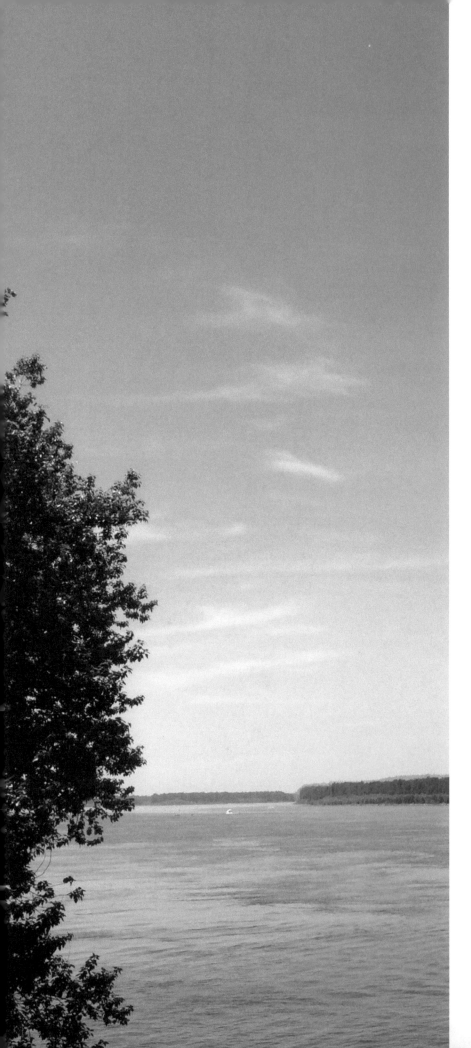

The Columbia

Two men explore me
Only the first to enter will have me

Lieutenant Broughton,
Captain Vancouver,
You seek my waters,
You claim my mountains,
You claim my island,
All still recall: Vancouver, Hood.

Captain Gray, is that you?
Oh yes, the man who knew
I was here
Before he ever saw me;
The man who knew my bounds,
When all others doubted thee;

You claim my mouth,
It is meant to be;
I am forever yours

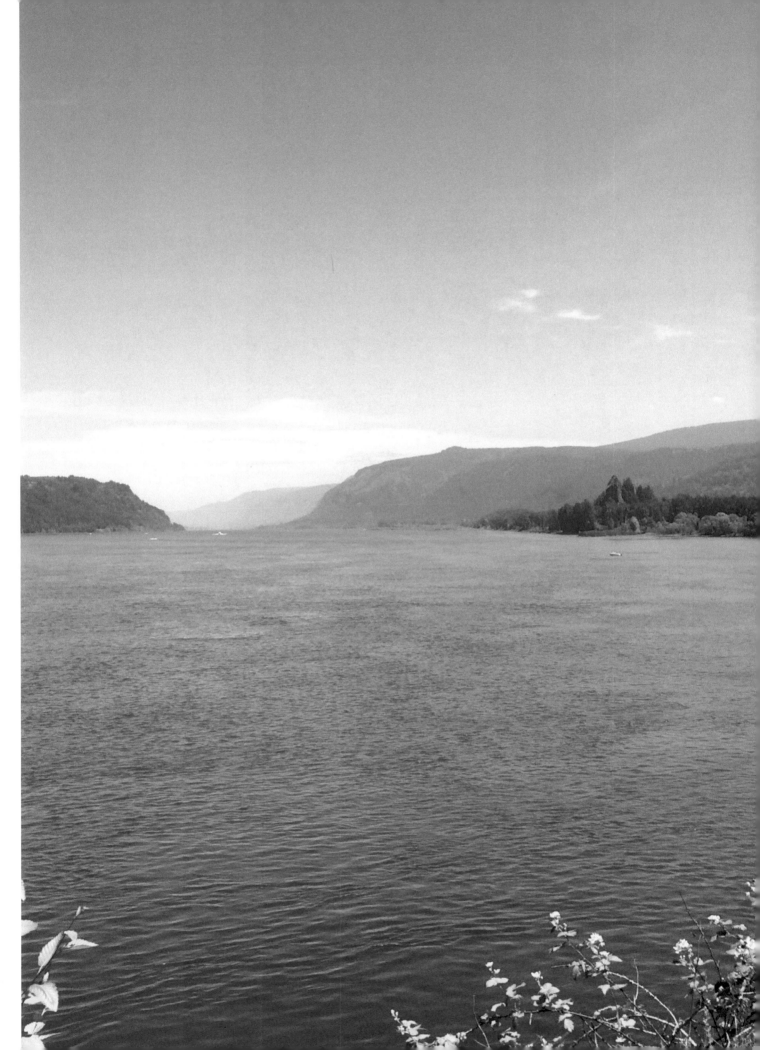

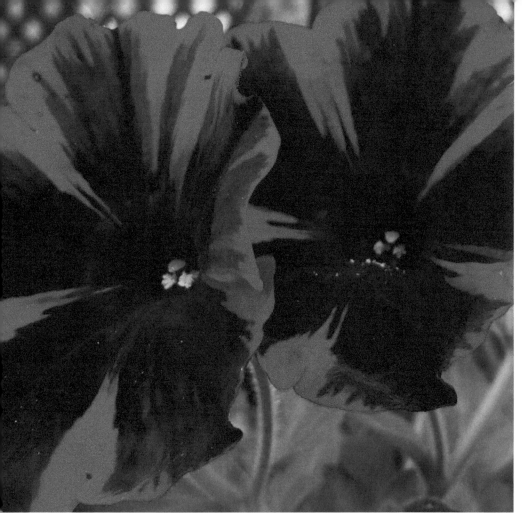

Lovers' Secret

They meet
In secret

Will he keep it?
Their secret?

She lusts
She trusts
She must

For their hearts are bound
There is no way around
True Love

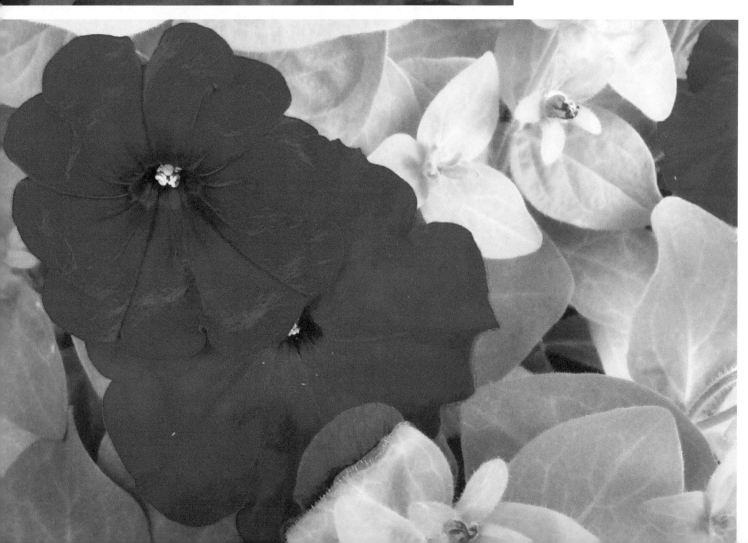

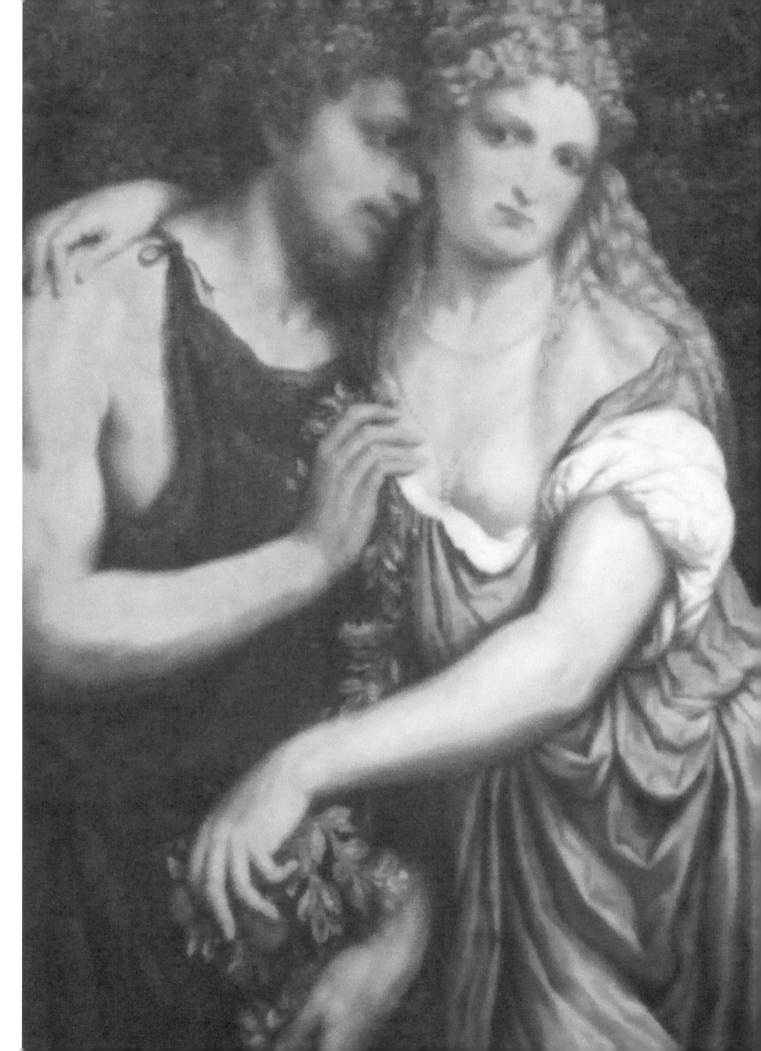

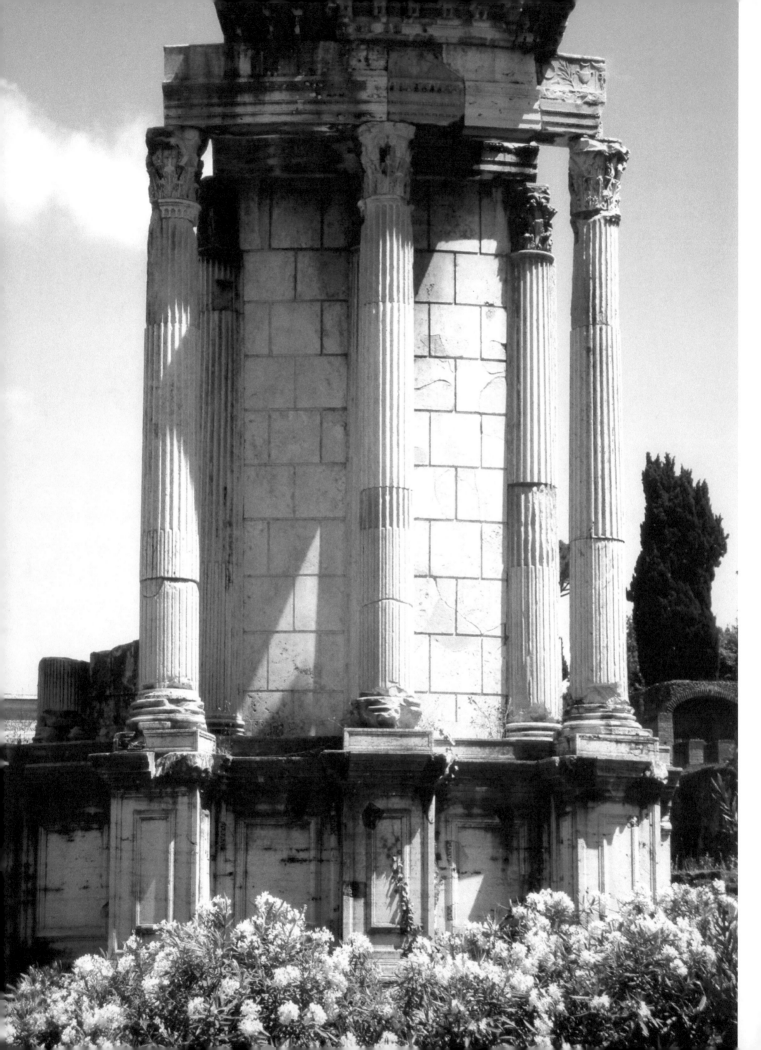

CLEOPATRA ~ MARC ANTONY

Cleopatra,
Marc Antony,
They could not defeat thee

Not Octavian
Nor his assumed, unfitting name,
Gaius Julius Caesar,
Not he!

For your flowers still grow
Where your memory does flow;

Rome thinks its stones
Capture memories of your bones

They do not!

Your LOVE lives on,
Tis *THAT*,
We remember most

Your ghosts,
Cleopatra,
Mark Antony,
Rendezvous here, with Glee

He Loves Me, He Loves Me Not

He loves me,
He loves me not

Or, so I thought

He loves me,
He loves me not

He loves me,
I am caught

He loves me,
No, he does not

He loves me,

Treachery is all my heart has brought!

He loves me not!

. . .

No, . . . I shall not be distraught . . .

He loves me!

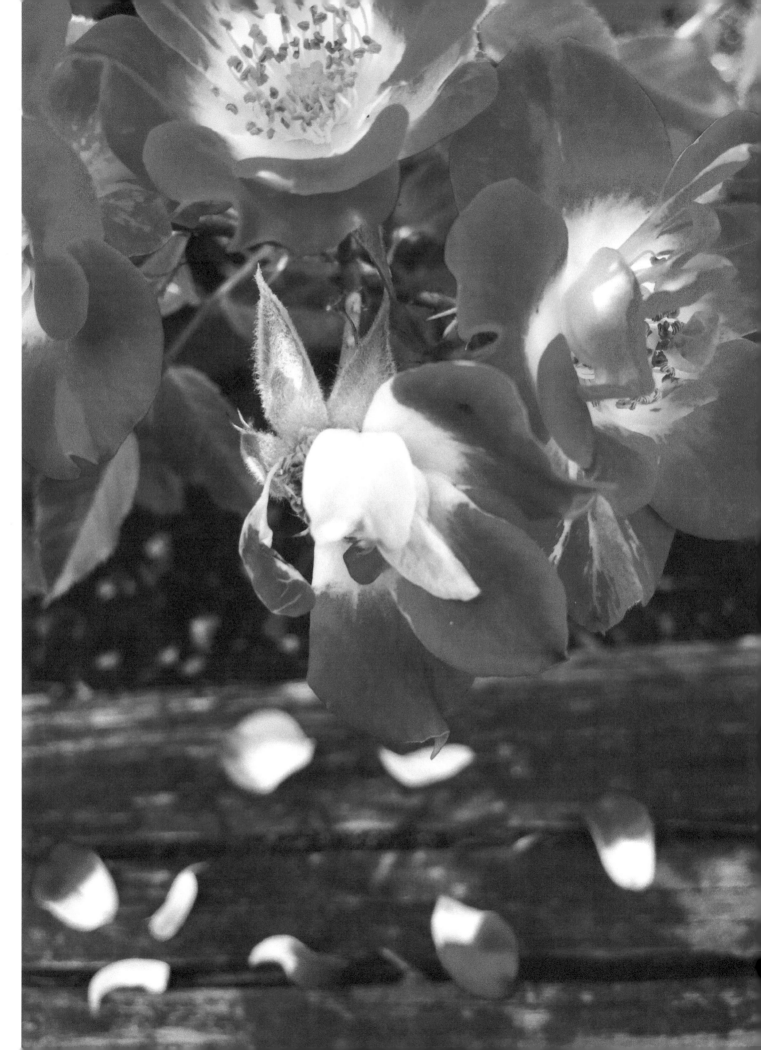

CUPID & PSYCHE

Beware Venus,
Dear Psyche,
You must flee

No, I do not fear
For Cupid Loves Me!

Psyche BeWare!
You MUST FLEE!

No! For I am Psyche!
And Cupid Loves Me!

~ ~ ~

On the story went . . .
And Psyche did not flee
She was the fairest of the land,
Venus could not bear to see

~ ~ ~

"A Goddess, you must be!"
Said Cupid to Psyche

Then a deep red blush, did she

"No mere mortal, could be as
Fair as thee,"
Said Cupid, on bended knee

And deeper, and deeper red, a
Blush, did she

Dear, Cupid, you flatter me

"Tis the truth, not Flattery!"
Said Cupid, on bended knee

~ ~ ~

Twas not his bow, nor his arrow
That pricked he,
Cupid was in Love with Psyche

Fairer than a Goddess, was she,
though merely a mortal;
Venus would not let it be . . .

~ ~ ~

Flattery became true
And Psyche soon knew
Fairer than a Goddess was she;

But Venus could not let it be!

Psyche frolicked with glee,
Worry free
For a God above,
The God of Love,
Indeed, fell in love,
With mere, mortal, Psyche;

Too Proud . . . Too Carefree,
Fatally wrong, was she

For Venus was Goddess,
Daughter of Zeus!
And revenge was her hangman's
Noose
No, . . . something more violent,
More vile, something that would
Last awhile . . .

Venus knew just what to do
with innocent, naive Psyche,
Fairest of the lands, Venus would
NEVER let her be!
Not when even the Heavens
Agreed!

Down, down to Hades,
Venus would send
Poor, mortal Psyche

~ ~ ~

For Cupid, I toil,
For Cupid I cannot spoil,
Love so precious, only the Heavens
can foil

~ ~ ~

Psyche nearly failed
But divinity always prevailed . . .

Each task she did complete
With heaven's help replete;

Until Venus sent deceit

"A box of beauty," said she;
Though it contained sleep, eternally

When Psyche did peek,
Her breath became weak,
and soon she was asleep

~ ~ ~

Hurry Cupid, Hurry!
You must fly, fly with fury!

And so did he,
Nearly, though not, untimely

~ ~ ~

"Psyche, you must breathe!"
Cried Cupid, desperately

"Breathe, Psyche Breathe!"
Whispered Cupid, vehemently

Then a kiss,
What great bliss,
Finally . . . The God of Love
Awoke Psyche!

Now a Goddess, truly,
She shall be;
Wife of Cupid for all eternity

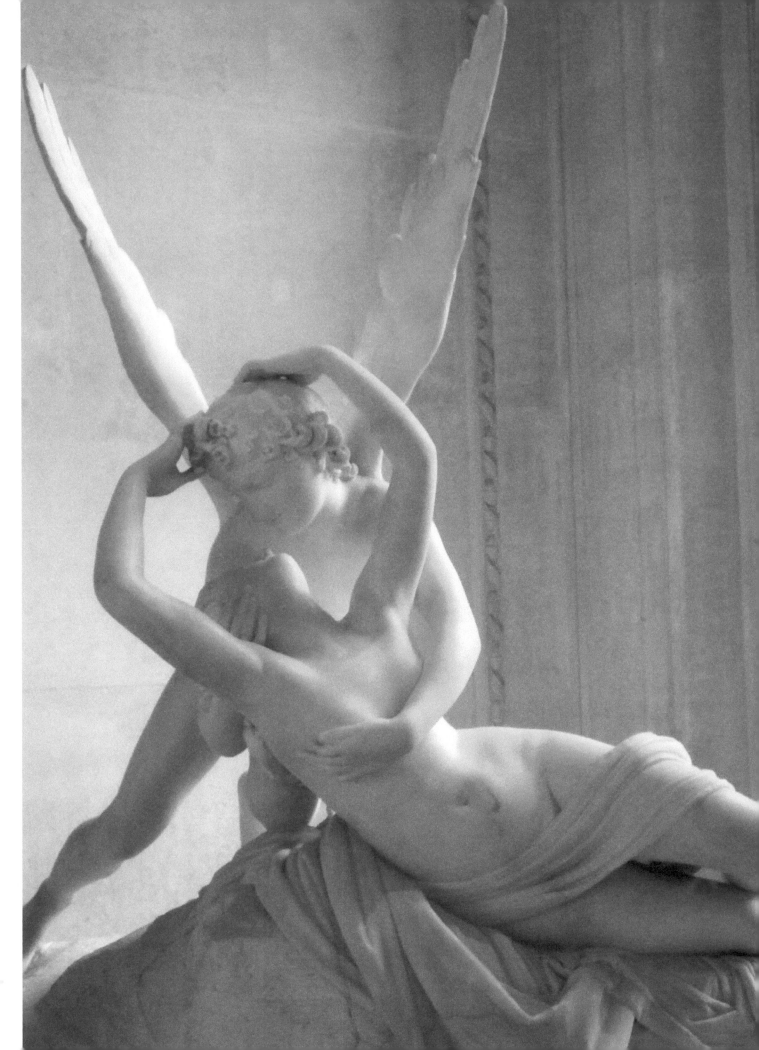

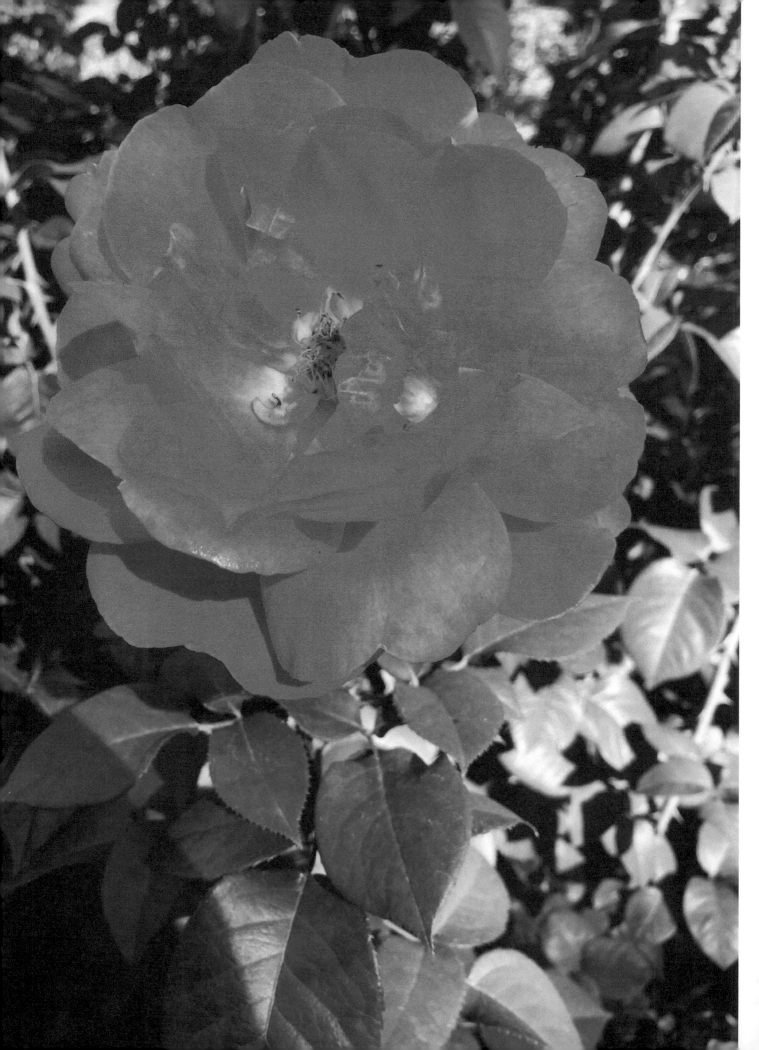

ROSE PETALS

Beauty is frail
But love never fails

This rose is but a symbol
Of your beauty, though nimble

Tis your soul, and your heart,
Cannot be captured with art

These petals may fall
But my love withstands all

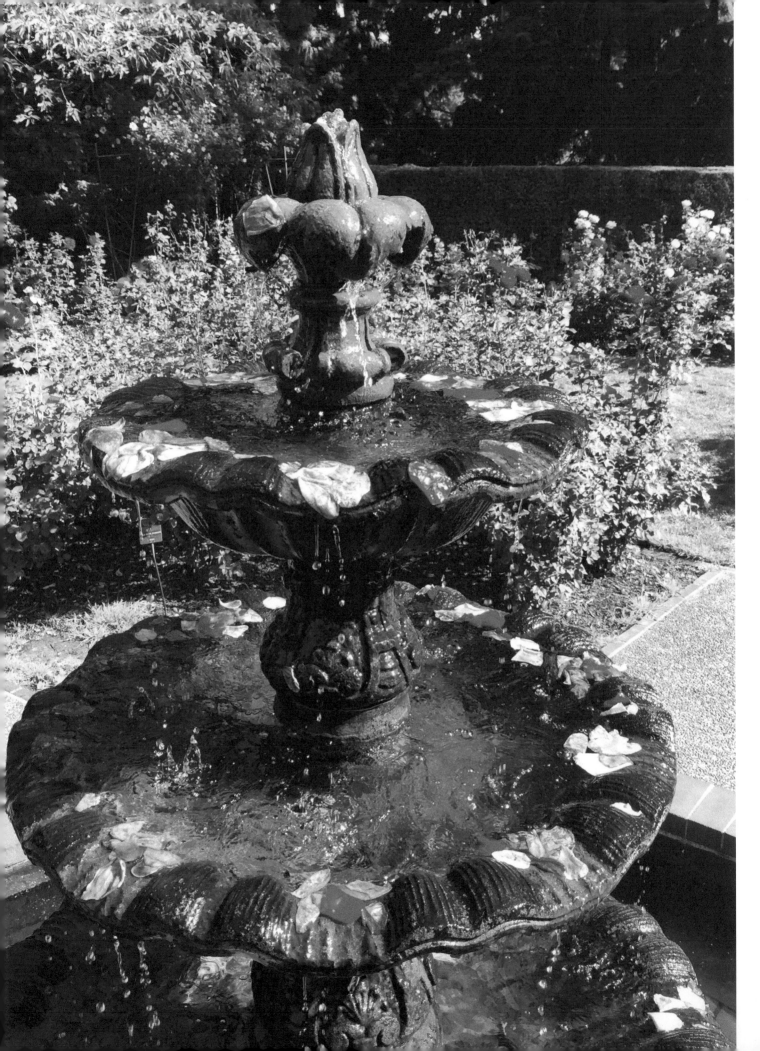

FOUNTAIN

They seek the fountain of youth;
But I have found it

In your smile,
Your eyes,
Your laugh,
There's no way around it

Your face,
No other place,
Grants me youthful energy,
as does your grace

Please embrace
me
And fill my heart's space
with glee

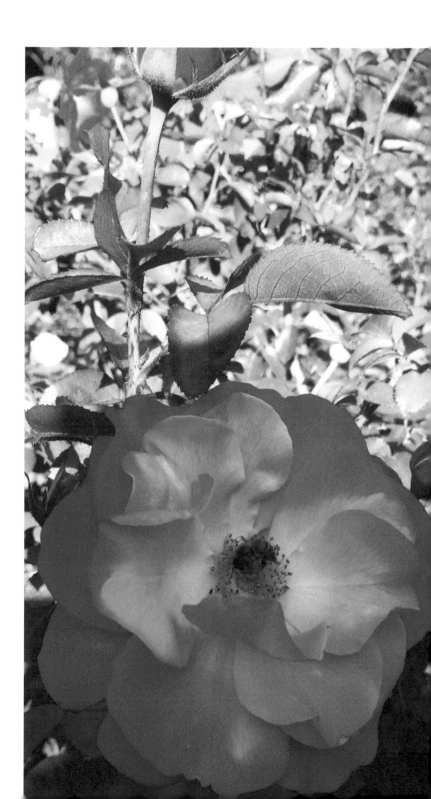

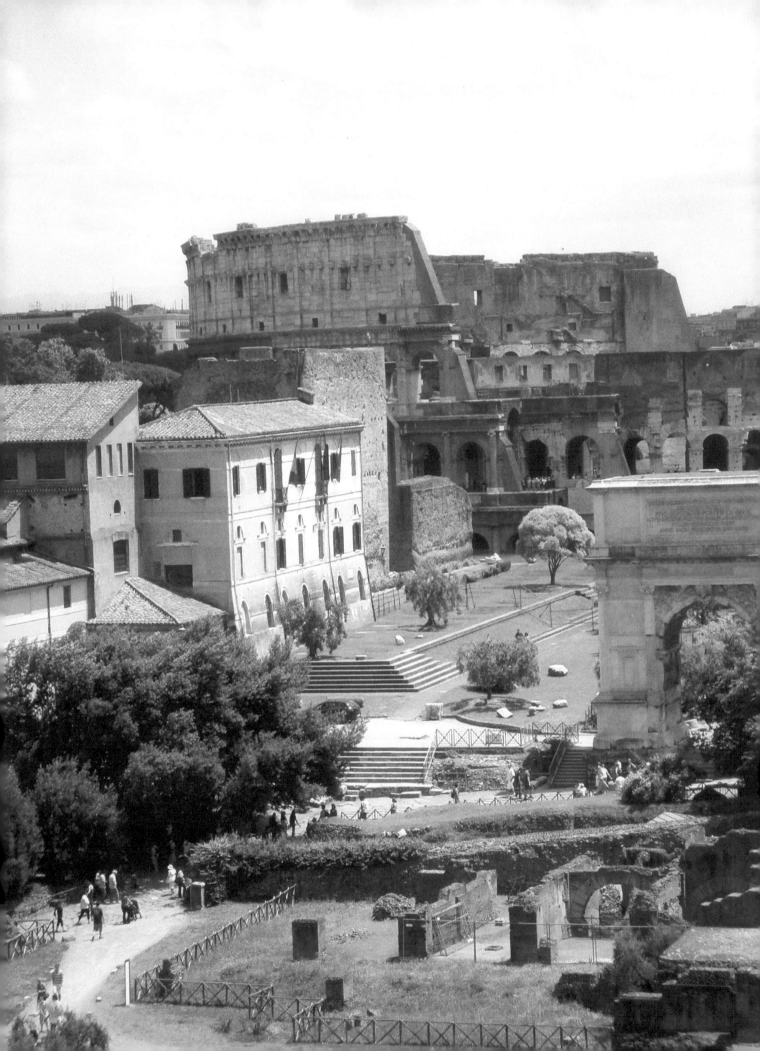

Julius Caesar

Julius Caesar,
Son of Venus, Favorite of Fortune, the most beloved of all men;
Julius Caesar, greatly loved, both now and then

Benevolent, powerful, extraordinary General;
Revered in triumph, your memory stays tall

Greatest of generals, capturing the world, in conquest;
And even better a lover, you were, Queens can attest

With passion you fought;
With passion you thought;
With passion, your plan was fraught

For you loved Rome, and She you,
Though your friends were not true;

Kind, generous, forgiving General,
You conquered the world, then forgave it;
Gave your enemies a voice, but your friends forbade it;
True to democracy -- possibly the creator who made it;
Too early in history, your contemporaries could not take it;

A voice to all?
Even Gaul?

Loved and hated; hated, without cause
Treachery, Deceit, Envy revolved
On that stormy night, raging on,
Thunder, lightning,
Frightening,
Gods and Goddesses alike,
For, even in heaven, there was a fight

As thunder rolled,
Doom took its toll,

On the Ides of March

(continued on next page)

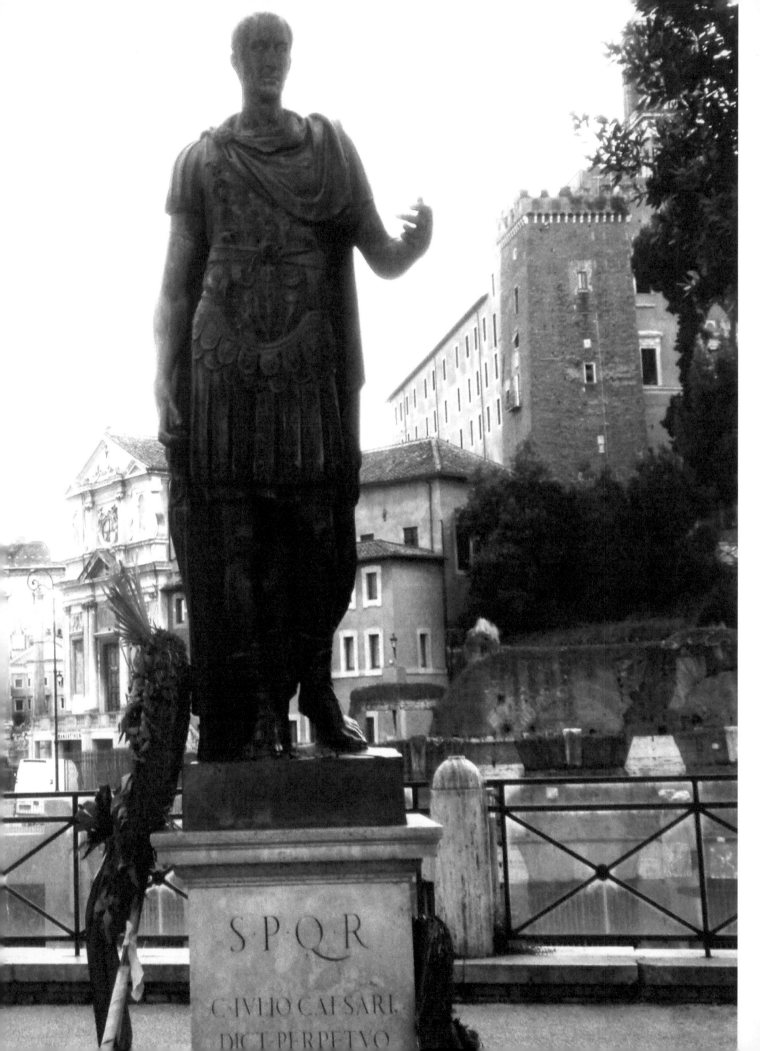

Julius Caesar
(continued)

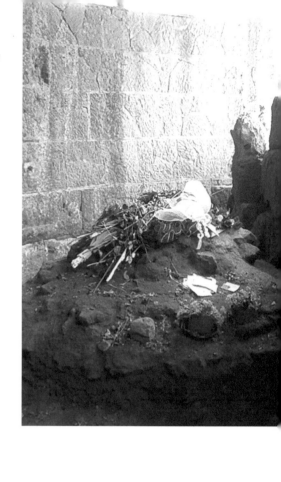

Brutus, the brute, so brutally took your life
Chaos in the Senate House; all about, there was strife
So many daggers, so many thrusts, from those you did trust
A nightmare was now real life
You did not heed the warning of your wife

Marc Antony grieves you
His memory never leaves you
In your name he will fight
Until all is right

To all Romans, he read your will
And to this day, they love you still
You gave your Villa and 3 golden pieces,
To every person on every Roman hill

Then it was known,
All you did, you did for Rome

Thus, your statue still graces,
Many great places;

and

At your grave,
They mourn you still

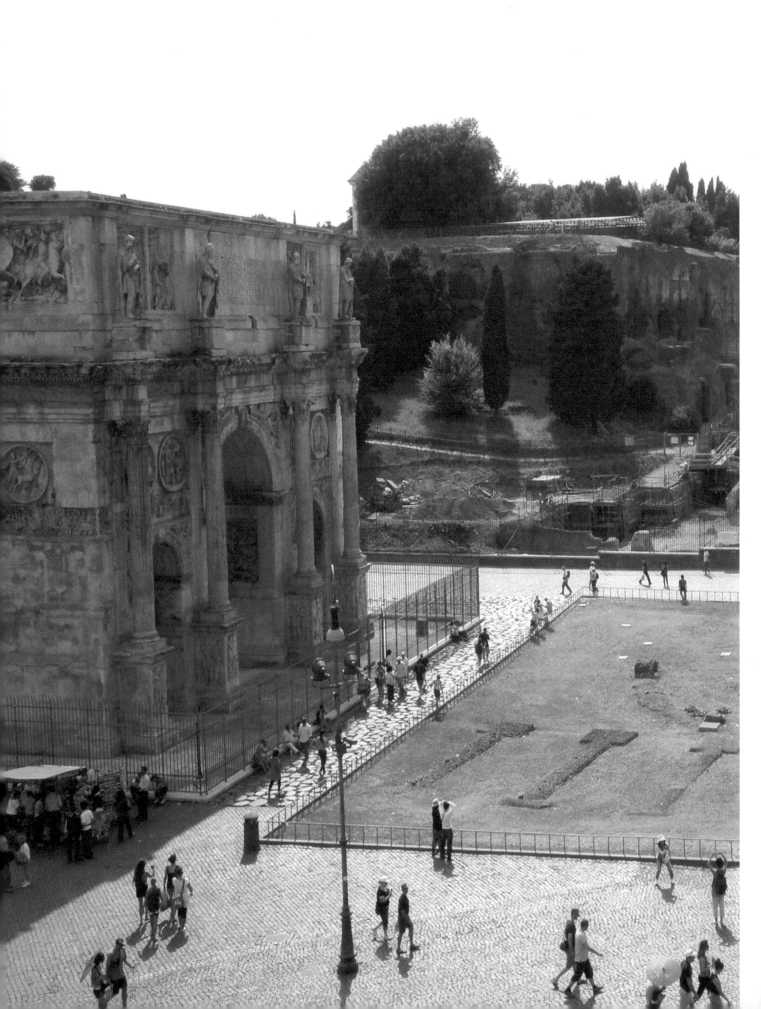

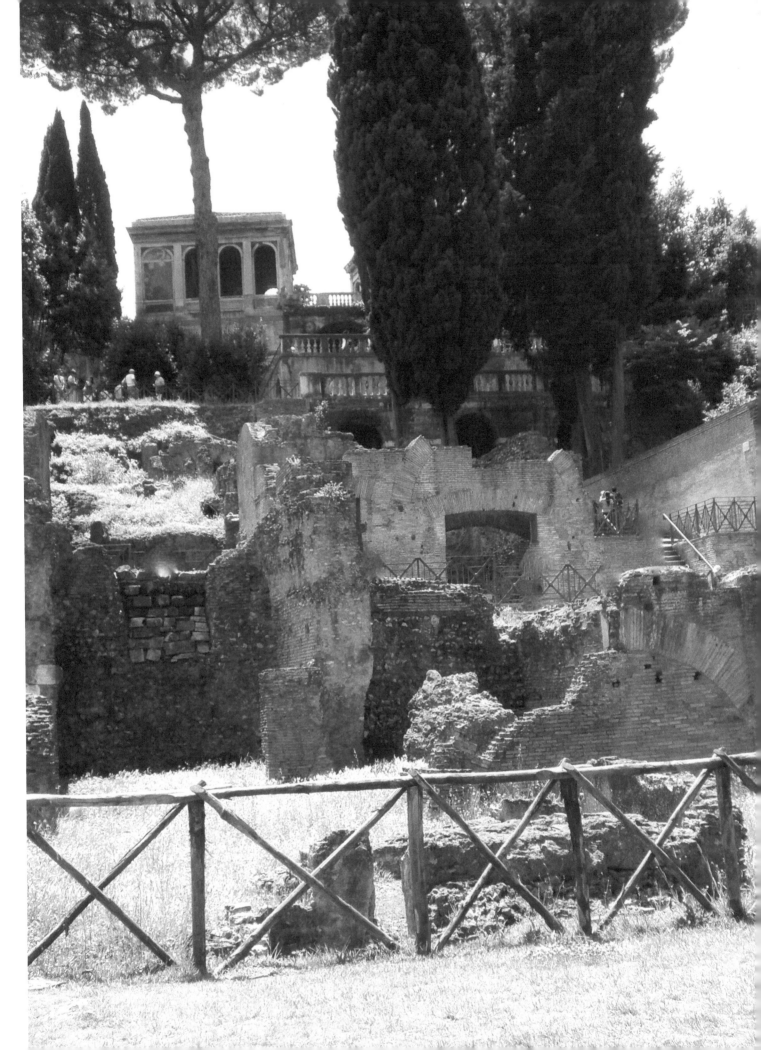

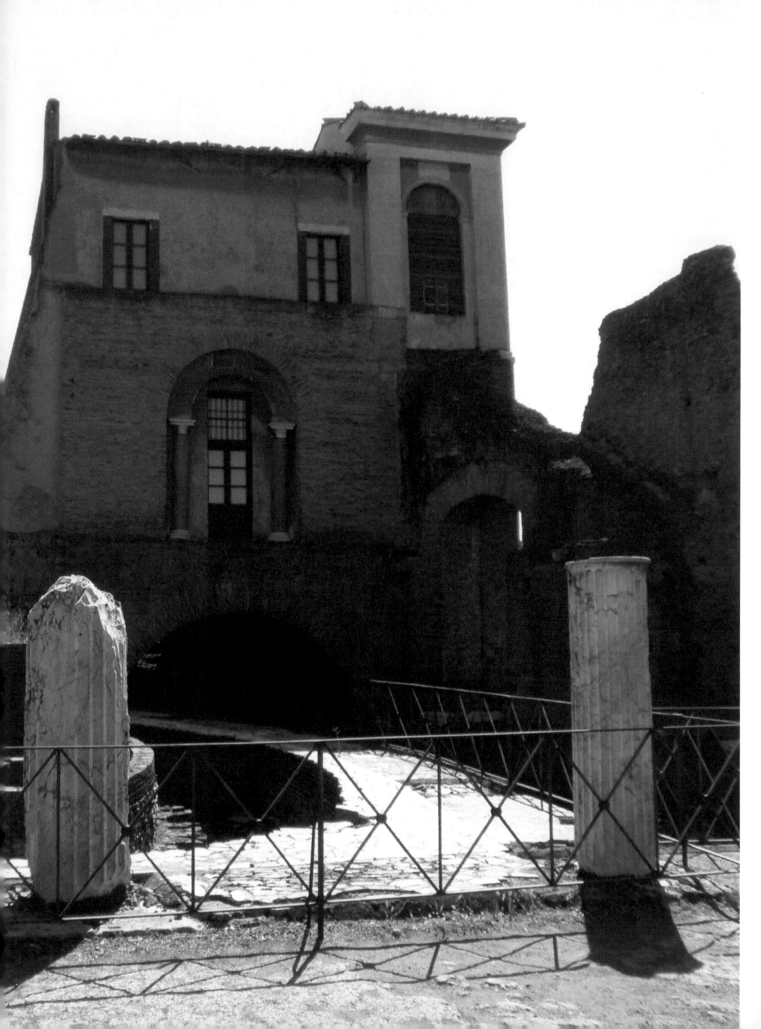

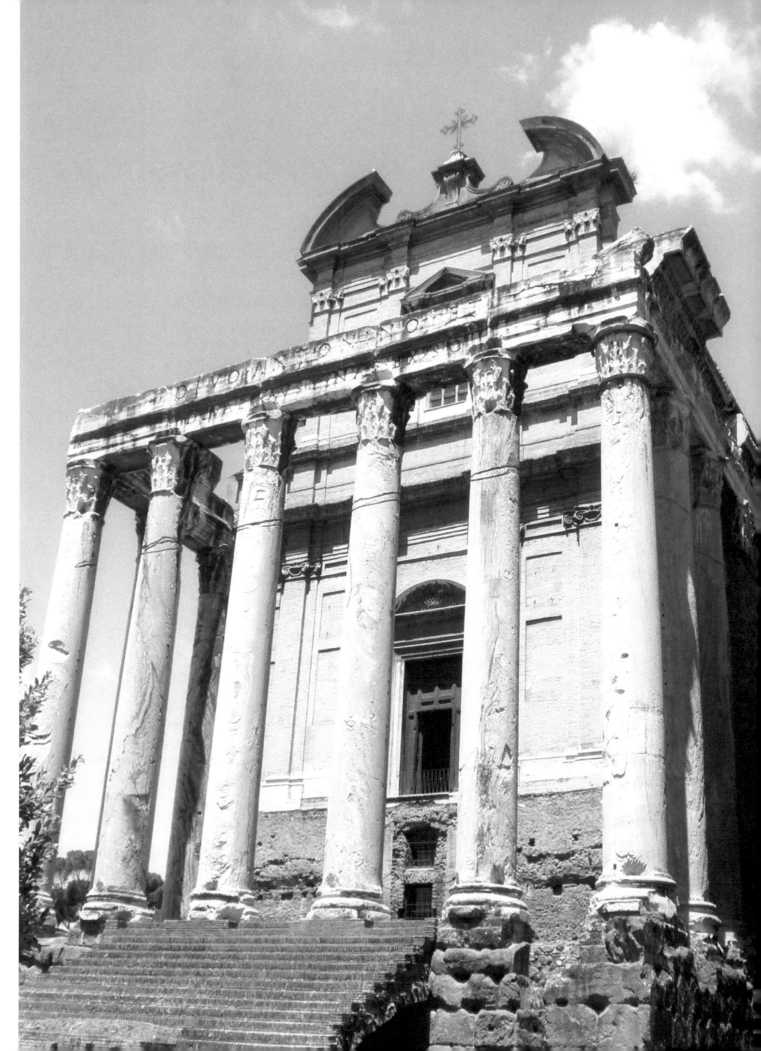

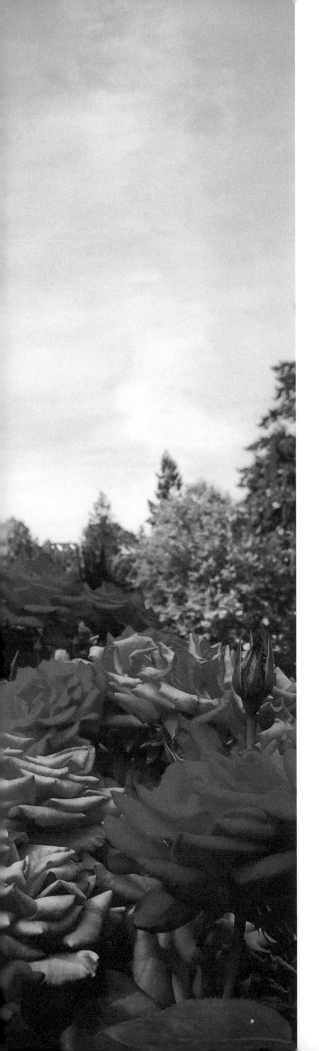

Meet Me In the Rose Garden

Meet me in the Rose Garden
Where I shall beg your pardon

Meet me in the Rose Garden
Where unhappy memories shall be forgotten

Meet me in the Rose Garden
Before our hearts shall harden

Meet me in the Rose Garden
It is not too late, my Darl'n

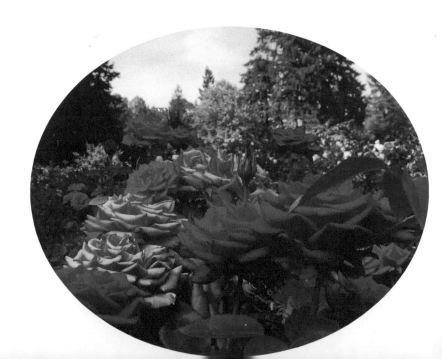

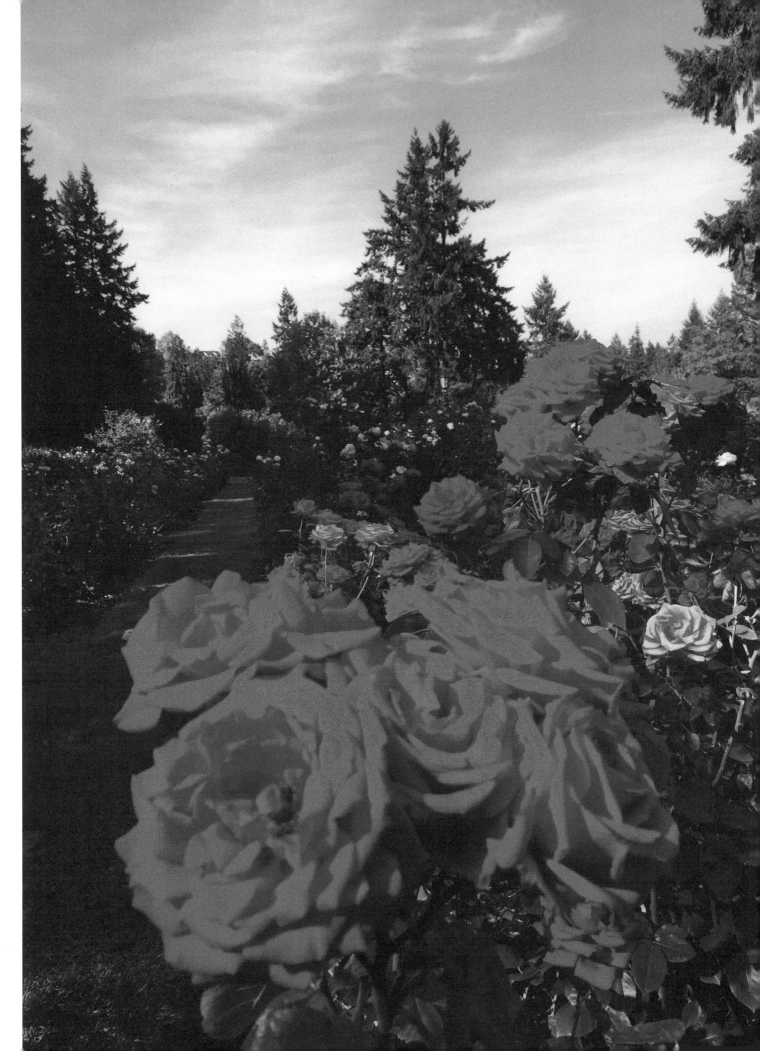

MYSTERIOUS MAN

Mysterious man, with eyes so blue,
Mysterious man, who are you?

Mysterious man, I fell in love,
But, really, Who are you?

No. Really, Who are you?

You come, You go,
Frequently,
as the wind does blow

Passion,
A deep kiss,
Many nights, full of bliss

These things I miss
Mysterious man, where are you?

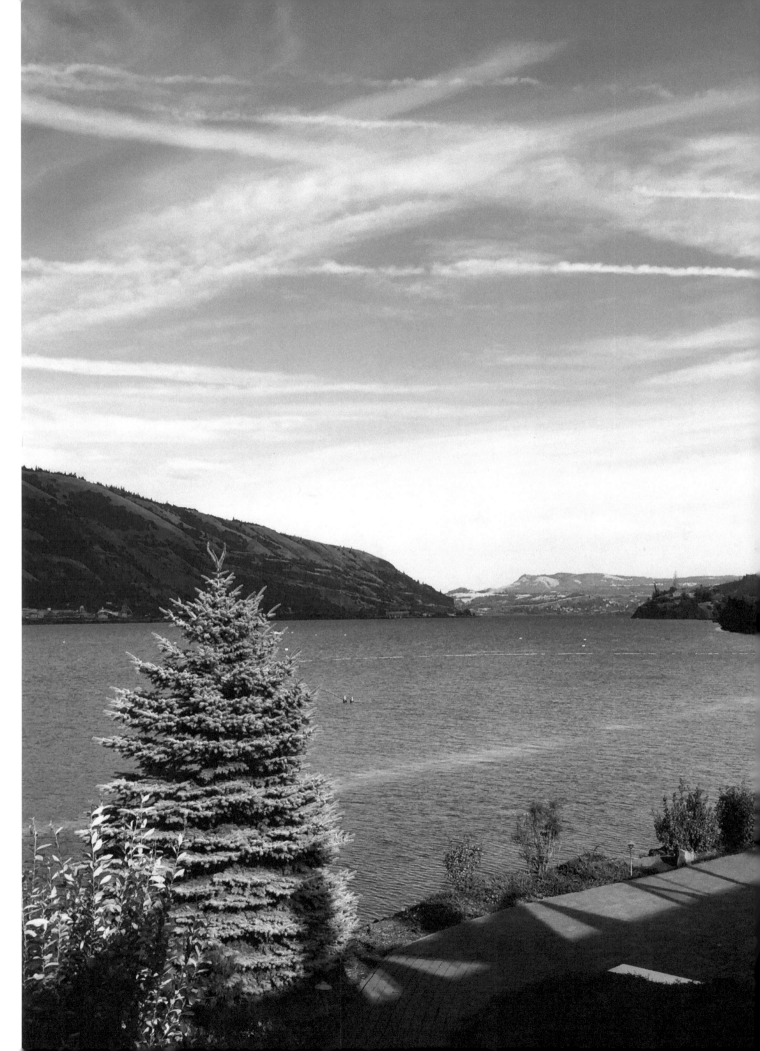

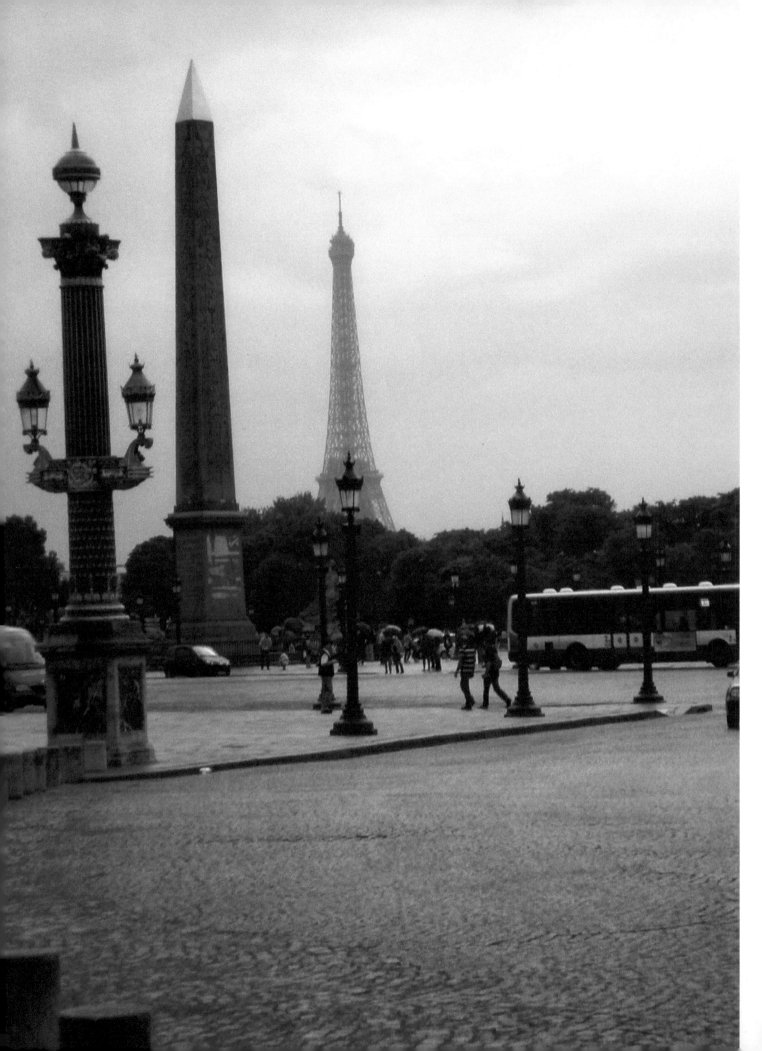

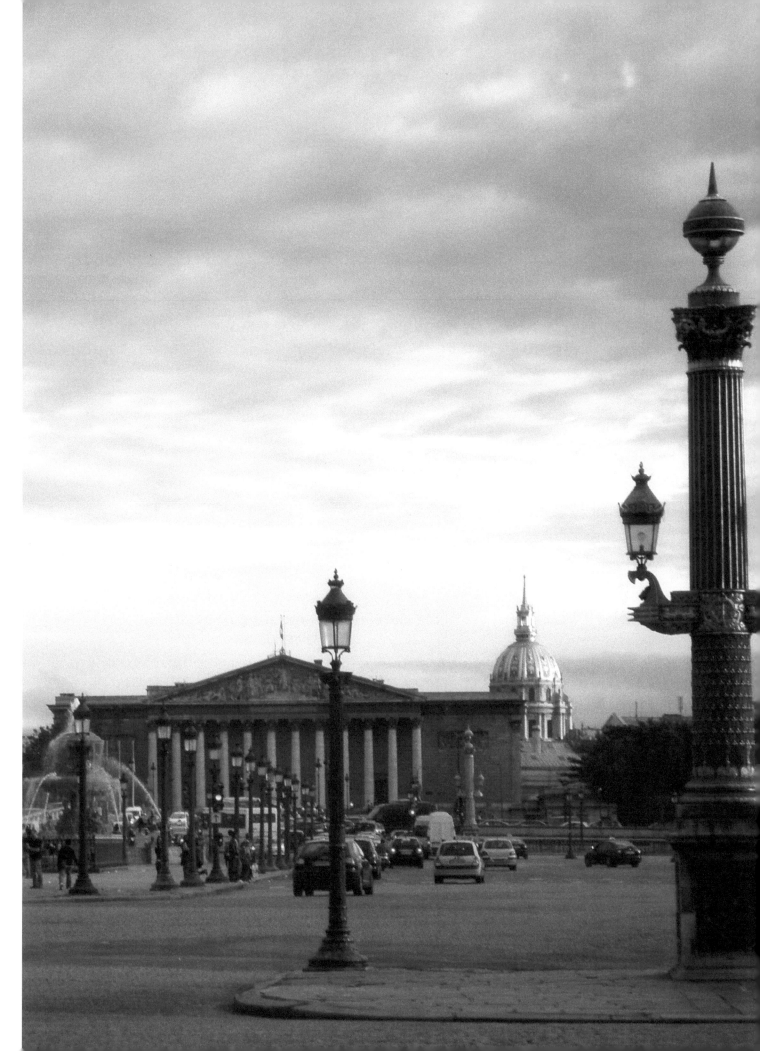

INDEX OF POETRY

This book intentionally omits page numbers, so as not to distract from the beauty of it. Below, is an index of poems, listed in the order in which they appear, herein; and the inspiration behind each one, as discussed by the author. Please enjoy!

AND POETIC INSPIRATION

POEM: **INSPIRATION:**

"Cleopatra ~ Mark Antony" - Inspired by the Roman ruins pictured alongside the poem. The photograph depicts what is left of a structure built by ancient Romans to commemorate Rome's defeat of Cleopatra and Marc Antony. It is the only structure in the Forum, in Rome, which had wild flowers growing at its base.

"He Loves Me, He Loves Me Not" - Inspired by the flower pictured alongside the poem, which the author found, naturally in that condition, in it's natural environment. And of course, it triggered thoughts of a favorite childhood game, named: "He Loves Me, He Loves Me Not."

"Cupid & Psyche" - Inspired by the author's most favorite work of art in the Louvre, in Paris France. The artwork is pictured alongside the poem. It is a statue, which depicts the moment in time, when Cupid revived Psyche from death with his kiss, after she was killed by his jealous mother, Venus. This ancient Greek and Roman myth is the foundation of many, many fairytales retold over and over throughout the ages. It's the reason we believe today, that any curse can be broken with true love's kiss.

"Fountain" - Inspired by a fountain romantically nestled among gorgeous roses, which is pictured alongside the poem.

"Julius Caesar" - Inspired by the historical figure, Julius Caesar, and by the author's visit to the Forum in Rome, which is depicted in several photographs pictured alongside the poem and in the few pages that follow. Most inspiring for the author, were the fresh roses and cards left at Julius Caesar's grave, which are still left for him today (pictured alongside the second half of the poem, with a statue of Julius Caesar). Other photographs include, a view of the coliseum from inside the forum; an ancient court-house atop a hill in the forum; a view of the Arch of Constantine from inside the Coliseum; the home of an ancient emperor; and the Temple of Antoninus and Faustina, built in 141 AD by a Roman emperor for his wife. Built for love, it is one of the best preserved structures in the Forum.

"Meet Me in the Rose Garden" - Inspired by the beautiful scene pictured alongside the poem.

"Mysterious Man" - Based on a true story; though the author will not tell us who.

ABOUT

August Summers is an attorney, author and photographer. She lives in the Pacific Northwest, and loves to travel. She practiced law for fifteen years before she began writing novels. Her novels include romance, women's fiction, and legal drama.

After unleashing her creative side, the poetry within her began to flow. She quickly found herself waking up in the middle of the night to jot down a poem. Poetry began writing itself in her mind as she drove home from the Columbia River and other awe inspiring places. Ms. Summers decided to put that poetry to pictures in order to produce this lovely book, so that she may share with you her passion for all the wonderful things captured herein.

From Paris to Rome to the Pacific Northwest, August Summers hopes to indulge your senses in the exquisite beauty that such places have to offer and the romantic senses that each place conjures up in its own unique way. From ancient Roman architecture, to her favorite works inside the Louvre, to the wonderful beauty that nature has bestowed upon the Pacific Northwest, there is something for everyone in this book, which August Summers hopes you'll proudly display on your coffee table and share with all your friends.

All the poetry and photography contained in this book, are the work of August Summers. Upcoming novels to watch for, by August Summers, include:

A Brush with Love, A Brush with the Law

White Jr.'s Trial

How Bad is the Boy

The Suspect

Cleopatra Now

To stay updated on new releases by August Summers, follow her on her social media accounts listed on the next page.

THE AUTHOR

FOLLOW THE AUTHOR AT:

Website: www.augustsummers.com

Twitter: @summers_fans

Facebook: www.facebook.com/author.augustsummers

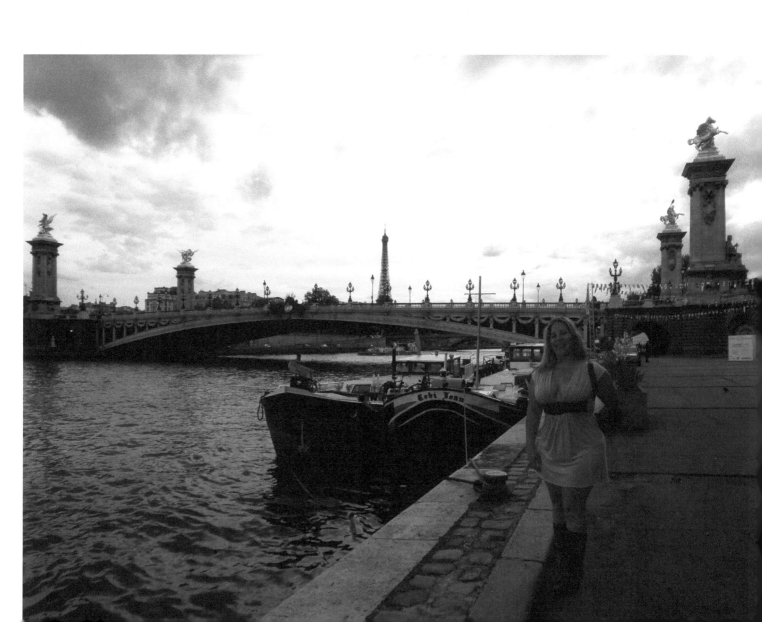